Reflections
of the Heart

Reflections *of the* Heart

Me, Jesus and Wal-Mart &
Coming of Age God's Way

REGINALD GENTRY

Copyright © 2016 by Reginald Gentry.

ISBN:	Softcover	978-1-5144-8194-3
	eBook	978-1-5144-8193-6

All rights reserved. No part of this book may be reproduced or transmitted in any form or by any means, electronic or mechanical, including photocopying, recording, or by any information storage and retrieval system, without permission in writing from the copyright owner.

Any people depicted in stock imagery provided by Thinkstock are models, and such images are being used for illustrative purposes only.
Certain stock imagery © Thinkstock.

Scripture quotations marked KJV are from the Holy Bible, King James Version (Authorized Version). First published in 1611. Quoted from the KJV Classic Reference Bible, Copyright © 1983 by The Zondervan Corporation.

Print information available on the last page.

Rev. date: 04/04/2016

To order additional copies of this book, contact:
Xlibris
1-888-795-4274
www.Xlibris.com
Orders@Xlibris.com
738714

CONTENTS

ME, JESUS, AND WAL-MART

Dedication ..5
Acknowledgement ...7
Introduction ...9
Chapter 1: Weathering Wal-mart .. 11
Chapter 2: My personal perspective .. 15
Chapter 3: Comparisons to Wal-Mart 16
Chapter 4: The three basic beliefs .. 18
Chapter 5: An Ode to Sam Walton ..20
Chapter 6: Poems for meditation ...21
Conclusion ...27

COMING OF AGE GOD'S WAY

Acknowledgements ..37
Introduction ...39
Chapter 1 ...41
Chapter 2: Let's reason before him ..45
Chapter 3: We must serve the Lord .. 46
Chapter 4: God is not mocked ...47
Chapter 5: "Here I am send me" ..48
Chapter 6: Building up God's House49
Chapter 7: Upon this rock ..51
Chapter 8: We must be born again ..52
Chapter 9: Requirements for coming of age in God53
Chapter 10: Benefits of Coming of Age God's Way55
Conclusion ...57

ME, JESUS, AND WAL-MART

"THOU SHALT LOVE THE

LORD THY GOD WITH

ALL THY HEART,

AND WITH ALL THY

SOUL, AND WITH ALL

THY MIND."
Matthew 22:37

"THY

SHALT

LOVE

THY

NEIGHBOR

AS

THYSELF."
Matthew 22:39

Dedication

This book

Is

Dedicated

To

All

Who

Seek wisdom from the Lord.

Acknowledgement

I'd

Like

To

Acknowledge

God

From whom
All
Blessings
Flow.

Introduction

Team playing dates all the way back to biblical times. I Chronicles, chapter 11, speaks of how King David had mighty men of valor to accompany him into battle. David was king over the Israelites. But, he also knew how to be part of the team. Jesus, was also a leader. But you can read in the new testament how he recruited twelve men, later called disciples to accompany him. The names of the twelve men that witnessed all of his miracles, were Simon, who is also called Peter, Andrew, his brother, James the son of Zebedee, and John, his brother; Philip, and Bartholomew; Thomas, and Matthew, the publican; James the son of Alphaeus, and Lebbaeus, Simon the Caananite, and Judas Iscariot.
Matthew, chapter 10

Chapter 1

Weathering Wal-mart

Wal-Mart is a lucrative, rewarding, challenging, fast paced, and trying business. How, you may ask? Because I work at Wal-Mart, and I'm right in the middle of it. The good, the bad, and the ugly. You never know from one second to the next what the atmosphere and environment is going to be like.

Of Course, we have our day to day responsibilities, but you never know, mind you, what monkey wrenches and kinks are going to be included. I came to the spectacular world of Wal-Mart, probably like many of my comrades, wet behind the ears, and excited about my new job at Wal-Mart.

But that job, Lord have mercy, became a career. I didn't come really expecting to stay on the ship Wal-Mart for 26 years. Many of my comrades, too numerous to mention, really broke me in, and taught me the ropes well. I learned very quickly that you must put out and produce, working for Wal-Mart. You learn quickly on the ship Wal-Mart. You learn how to do many things simultaneously. With Wal-Mart, every second counts. My hat's off to two comrades/associates who made my career in the early days, less painful, less stressful, and more enjoyable. Allen Williams and Lynn Breeden taught me the importance/value of having a work ethic. A shout out to Allen E., and Lynn B., and

all my fellow associates. Go Huntingdon 161. You're the greatest. I love you guys.

You have to look at your job/career as something you can have fun with. If you can't make your job/career fun, and despise what you're doing, you're not going to last on the team Wal-Mart, or any team.

Wal-Mart or any other company is a team effort. But face it, there's going to be those who don't care a flip about being on a team, Wal-Mart's or no one else's. Brethren, let's face it, those types make it hard to maintain your momentum/flow. I've had to pray a whole lot, and bite my tongue since being at Wal-Mart. Believe it or not, I have even wanted to quit, say goodbye, and to heck with it. I'm not one to give up easily when I believe in something. I thank God for blessing me down through the rough years since I've been employed at Wal-Mart.

I'm not going to lie and say that it hasn't been tough sometimes during my 26 tedious years with the company. I have made it by pumping myself up, and saying it's going to get better, and it has, with God, through Jesus Christ by my side. It's been a tough ride, but I'm making it, me, Jesus, and my fellow Wal-Mart associates in my corner. Wal-Mart's about taking it to the limit, over and over and over again. It's about taking a breather and diving right back in.

Wal-Mart's three basic beliefs: 1). Respect for the individual, 2). Service to the customer, and 3). Striving for excellence, are great concepts.

Sam Walton, with the Lord's help and guidance, and his hard work, founded a great company. It's not without some kinks, but what great company doesn't. Whether it's Facebook, Microsoft, IBM, Coca-Cola, or whoever, it's not going to flow one hundred percent like you want it to. I'm proud of Wal-Mart.

I started out in receiving, having minimal contact with the customers, but now, hallelujah, I can interact with them, smile at them, and assist them on a day to day basis. I'm not saying that every customer that you practice the ten foot rule with, is going to be exciting to encounter. But it's my job, and my duty to God through Jesus Christ, to remain friendly, courteous, polite, and optimistic at all times.

Life is so disappointing and discouraging sometimes, but you have to keep on pressin' and say hallelujah, anyhow. People/customers don't have to be ugly, but it's part of the Human condition. The human condition is a given, you can't dodge or wish it away. We were created in God's image, but that ugly spirit is still taking up residence inside of us. But, praise God. Me, Jesus, and my fellow Wal-Mart associates are going to be alright, as long as we take Jesus, the anchor of life, along with us. As I reflect, and reminisce back over my beginning at Wal-Mart, It has been hard, but fun, challenging, but rewarding, stormy, but yet the sun always miraculously appeared. I recall thirteen to fifteen hour long days, preparing for inventory, making sure that everything was inventory ready, and making sure that everything that was not going to be inventoried, it had a D-N-I tag placed on it, which simply meant, do not inventory. I also reflect back on the privilege that I had to meet the founder of Wal-Mart, Sam Walton. He was as laid back, and down to earth as anyone you would ever want to meet. I've had the privilege and the honor of working the receiving area, unloading the trucks, sweeping the trucks, cleaning the dock areas, organizing the fixture room, stocking the sales floor, cleaning up the bathrooms, dust mopping the sales floor, being a Cart Pusher, working in the Garden Center, being on the safety team, and a short, short stunt as a Department Manager. Wow, I can truly say that me, Jesus, and Wal-Mart have definitely been through a lot of things, whew.

It has been challenging, and still is, but I thank God that I had the privilege and the honor of service to a great company likeWal-Mart down through the years.

As a meat associate, I still get the opportunity to do other things, as well as train new associates. I enjoy cleaning the meat department, stocking, doing markdowns, checking for out of dates, helping to make bales, and I still, praise God, get the opportunity to be a Cart Pusher, as well as an occasional stunt in the Deli department.

I have nothing but love for my Wal-Mart family, and for Wal-Mart as a whole. Oh yeah, there's an associate that I have had the privilege and the honor to work with on two levels, once as an Assistant Store Manager, and now, drum roll please, as my Store Manager, and that

associate is none other than Mrs. Mary Browning. My hat's off to her for a job well done.

I know that all of my fellow associates play a part in us being a successful store/family. I just wanted to give my appreciation to her. I can truly say that she has been the same in my retrospect, in both capacities. She may come on strong, overbearing, and firm, but Lord have mercy, she just wants a top notch store. I work with a great group of associates. I got nothing but love for you guys. Momentum, Jesus, and the three basic beliefs, those three are the key to a successful establishment.

Let's make Jesus and Sam Walton proud.

Chapter 2

My personal perspective

There would be times, whether it was winter, spring, summer, or fall, Satan, the enemy of the child of God, will creep into your mind on the job, trying to undermine what you are doing. "Why are you busting your butt trying to make Wal-Mart look good?

They don't care anything about you. You're not important to them. You're just a statistic to them," Satan would say to me. It would bring tears to my eyes. I could hardly shake it off.

"Why don't you just quit, and get it over with," he would say sarcastically. And I would tell Satan, the accuser, "If I quit, it will be in God's own time, and not because of you deceiving me."

God is so good. Sometimes it brings tears to my eyes, right there in the meat cutting room, while I'm working putting use by dates on the meat. It's been an interesting rollercoaster ride, my twenty six years at Wal-Mart. There has been bumps, and there has been a lot of smooth places, but the bottom line is this: Grab on, and hold on tight. A person can surely lose focus in the Wal-Mart shuffle.

The rewards outweigh the pitfalls and the monkey wrenches that are thrown your way. As I so stated before, Wal-Mart, or any other great company, retail, or otherwise, is full of changes and challenges.

The shuffle doesn't lighten up. It's a continuous stream of surprises, the unforeseen, and the unexpected.

Chapter 3

Comparisons to Wal-Mart

I'll put my experiences at Wal-Mart this way. It's like fitness training. You have to keep at it to see the benefits and results. I heard someone say: "No pain, No gain." Frustration, irritation, and aggravation, to name a few, are part of the territory. It goes hand in hand in the retail business, or any other successful business.

There's no quick and easy solutions, most of the time, but there are solutions and answers, nonetheless.

I enjoy being around people, communicating, interrelating, assisting, listening, and observing.

But I am a task oriented person, enjoying keeping my hands and my mind busy at all times.

Another example of what I compare my Wal-Mart career to: It's like bodybuilding, you have to take care of your body by eating right, getting an adequate amount of rest, and warming up before starting a muscle building program. A person has to endure many repetitional sets before seeing any noticeable results, and when the biceps, the triceps, the thighs, chest, shoulders, and leg muscles start to bulge and form, it makes the pain and agony from sacrificing through it all, worthwhile. A person is excited about what has been accomplished. A new, more contoured and more muscular physique has been born. Accomplishing tasks at Wal-Mart has much the same effect. The end result is more

material, than physical. The Wal-Mart Associate flex a mean muscle as a team, unlike the bodybuilder, which is an individual thing. A thing called stress, builds in the process of flexing a mean muscle during a team effort. It is worth it, to see everything come together throughout the Wal-Mart environment. Better than that, it's so amazing! Hallelujah! Thank God for The three basic beliefs that lay the foundation for what the Wal-Mart associates/family accomplish and achieve together.

Chapter 4

The three basic beliefs

Wal-Mart's three basic beliefs align perfectly with what God, through Jesus Christ, requires and expects out of each individual. Belief One: Respect for the individual. Every associate must Courtesy, kindness, and respect one another as a person first, and then as a member of team, Wal-Mart's team. But the ultimate, and foremost team that we should be pressin' to be a part of is God's heavenly team.

Matthew 6:33 puts it this way: "But seek ye first the kingdom of God, and his righteousness; and all these things shall be added unto you." We should be seeking the things that pertain to God. We should watch what we say to one another. We should choose our words carefully. Colossians 4:6 puts it this way:

> "Let your speech be always with grace, seasoned with salt,
> that ye may know how ye ought to answer every man."

Belief Two: Service to the Customer. We should always be ready and willing to do service for our fellow man, at Wal-Mart, or wherever. It's always a good time to lend a helping hand. Everyone needs a kind deed directed to them. Colossians 3:17 puts it this way: "And whatsoever ye do in word or deed, do all in the name of the Lord Jesus, giving thanks to God and the Father by him."

Belief Three: Strive for Excellence. We should do this not just on the job, but it should be a way of life. Philippians 2:14 puts it this way: "Do all things without murmurings and disputings." We must press toward the prize of God, through Jesus Christ. Philippians 3:14 states it like this: "I press toward the mark for the prize of the high calling of God in Christ Jesus.

Chapter 5

An Ode to Sam Walton

A man from Arkansas, he had an awesome
dream. He had so envisioned,
People connecting as a
Team. He didn't let nobody,
Rain on his parade. He was
so determined, what a
difference he has made.
That man is Sam Walton.
Thank God for Sam Walton.

Chapter 6

Poems for meditation

SPREAD A SMILE

The world is so full of draining obligations.
Life is climbing mountains
of higher elevations.
Just keep it all in perspective.
It's okay, to be a little
reflective.
Life is all about spreading a smile.
Yes my friends, life is
worthwhile.
Keep your head up, through life's
Atrocities.
Remember, my friend, that life
is filled with numerous
Possibilities.

I AM ASKING

I am asking you

Lord, please.

I have no place to go but on

my knees. Rid me of my soul's disease.

And keep me from being possessed by

The grip of Mr. Freeze.

THE REAL DEAL

Jesus, he's the real deal.

Your soul, Mr. Freeze will try to steal.

His true colors, he'll try to conceal.

Your desires, he'll try to appeal.

In hell, that's not something that you should want to feel.

In heaven, now that's the way to chill.

STEP UP TO THE CALL

Step up to the call.

Don't linger, don't stall.

Let God catch you before you fall.

He sent Jesus, to be your all and all.

Don't fret, when your back's against the wall.

Find joy, peace, and love, in God's heavenly mall.

I AM 4 JESUS

I am 4 Jesus.
He's an epitome of God's unconditional Love.

I am 4 Jesus.
He's an epitome of God's amazing grace.

I am 4 Jesus.
He's an epitome of God's unspeakable joy.

I am 4 Jesus.
He's an epitome of God's indescribable sweet peace.

I am 4 Jesus.
He's an epitome of God's longsuffering toward us.

Conclusion

In all that we do, in all that we say.
Let Jesus be the ultimate solution to
our very busy day.
He's anticipatin'
our every
call.
Let Wal-Mart's three
basic beliefs,
help you to
stand tall.

Wal-Mart is a wonderful experience. It's a

challenging, but yet rewarding career.

They emphasize commitment,

dedication, and hard work.

Wal-Mart's three basic beliefs

Is an awesome concept, not just

on the job, but in your day to day

challenges.

Reginald Gentry
11870 Lexington St.
Huntingdon, TN 38344
731-307-5660
reginald.gentry@yahoo.com
Attended Humboldt High School, Humboldt, TN 38343
Attended Middle Tennessee State University, Murfreesboro, TN.
Minister at Morning Star Missionary Baptist Church.

Pastor: Rev. Quill J. Brabham
Leading Lady: Sis. Amanda Brabham

COMING OF AGE GOD'S WAY

COMING

OF AGE

GOD'S WAY
(Biblical lessons from
the word of God)

"I have been young, and now am old;
yet have I not seen the righteous forsaken,
nor his seed begging bread. He
is ever merciful, and lendeth;
and his seed is blessed.
Psalms 37:25-26

This book is dedicated to all of you who
yearn for the Lord.
All of you who thirst
and hunger after
righteousness.
Matthew 5:6

Doing it God's Way

If we aint doing it God's way, we'll spinning our wheels.
If we aint doing it God's way, we're
taking useless pills.
If we aint doing it God's way, we're
wasting our time, just a
lookin' for
short lived thrills.
Doing it God's way, involves unconditional
love. Doing it God's way, means swallowing
your pride when push comes to shove.
Doing it God's way, entails forgiving,
like Jesus does, from heaven
above.

Acknowledgements

I'd like to give a shout out to Almighty God for placing this gift in me.

Introduction

Coming of age God's way means to continue growing in the faith, growing in God's grace, to pray without ceasing, and to continue to rise to higher heights in the wisdom, knowledge, and understanding of God through Jesus Christ, Our Lord and Savior. Colossians 1:23-24, 2 Peter 3:18
I Thessalonians 5:17
People can pester us, persecute us, mock us, or whatever. We as children of God, must know who we are, and whose we are. We must tell Satan, I know who I am, and I know to whom I belong. Encourage yourself by saying, I'm more than a conqueror through Jesus Christ.
I'm the righteousness of God Almighty, through Jesus Christ.
Romans 8:37, 2 Corinthians 5:21

Chapter 1

God removes, and he exalts "The Lord exalts one, and abases or brings down another." Luke 14:11

"For man looks on the outside, but God, but God, looks at the heart." I Samuel 16:7.

Behold, it's best to obey God, than to present sacrifices, and to hearken than the fat of rams. I Samuel 15:22

Put the Lord first, and his kingdom. Matthew 6:33

Saul lost it all. He lost his kingship over Israel, and he lost his good name with the Lord, all because of his greed, pride, and disobedience. I Samuel 15

"In all thy ways acknowledge him, and he shall direct thy paths. Proverbs 3:6

"Trust in the Lord with all thine heart; and lean not unto thine own understanding." Proverbs 3:5

"The curse of the Lord is in the house of the wicked: but he blesses the habitation of the just." Proverbs 3:33

It's best to do what thus saith the Lord. "The wise shall inherit glory: but shame shall be the promotion of fools." Proverbs 3:35

"No good thing will the Lord withhold from the man that walks upright before him." Psalm 84:11 "The Lord shall increase you more

and more, you and children; continue to fear the Lord, both small and great." Psalms 115:13-14

Saul lost the kingdom of Israel. Saul thought that because he was a man of great stature he could do anything he pleased and the Lord would be pleased with it. But God proved him wrong. Samuel told Saul he had been rejected by God, because he had rejected to do the right thing in God's sight. I Samuel 16:26-29

The Lord would replace Saul from being king over Israel. Saul disobeyed God. I Samuel 15:22-23 The Lord sent Samuel to Bethlehem to sacrifice a cow, and he knew that Saul would be there too. God sent Samuel to Bethlehem with a sacrifice, because he knew that Saul would not take kindly to the situation of being dethroned. Jesse, the father of David would be there. I can imagine the situation getting ugly, but God showed up and showed out, because that's what a strong and mighty God does. All of Jesse's sons presented themselves before Samuel, but God refused and denied them all, but one. He chose scrawny David, the shepherd boy. Why? "For the Lord sees not as man sees; for man looks on the outward appearance, but God, looks on the heart." I Samuel 16:7

Samuel set his eyes on 10 of Jesse's sons, but none of them made the grade. Out of all of Jesse's sons, God, he chose scrawny David, a fair looking shepherd boy. God, he had great things in store for David, the shepherd boy. He had a divine, ordained plan strategically set for David. The things David accomplished, through God, blew his mind. He gave the credit and the high-fives to the God of his salvation.

The Lord Is My Shepherd

David gave the Lord God all the glory, and all the praise. He paid tribute to the Lord God, by writing the twenty-third psalm.

"The Lord is my shepherd, I shall not want." David knew he didn't have to want for anything, as long as he put all his trust in the Divine Shepherd. Our life would be a whole lot more victorious, if our trust is put on, and placed in the Divine Shepherd. King David knew all too well how God would bless and prosper those who trusted and depended on him. 2Samuel 24:25

David defeats Goliath (You can't judge a book by its cover)
1Samuel 17:42-50

Goliath was a philistine giant that came up against David,6 and the giant insulted and made fun of David, because "he was but a youth, and ruddy, and of a fair countenance." "And the philistine said unto David, Am I a dog, that thou comest to me with staves?" "And the philistine cursed David by his gods." David defeated the philistine giant because he found favor with God, and he did what was pleasing in the sight of God.

We all come short
Romans 3:23

Even though David was a man after God's own heart, he came short of God's expectations and requirements on occasion. He put Uriah, one of his soldiers, at the front of the firing line of one of the battles they were involved in, so that he would be killed, because he found Uriah's wife, Bathsheba, beautiful to look upon. 1Samuel, 11th chapter, Romans 3:23 We all come short and do things that we shouldn't do, but 1John 1:9, tells us that if we confess our sins, he is faithful and just to forgive us of our sins, and to cleanse us from all7 unrighteousness. Even at our best, we are still as filthy rags before an omnipotent God. "But we are all as an unclean thing, and all our righteousness are as filthy rags; and we all do fade as a leaf; and our iniquities, like the wind, have taken us away." Isaiah 64:6

God purges

David in I and II Samuel, and the Psalms, knew all too well what it meant to be purged or cleaned up from unrighteousness, and we too have things and habits that we need to be purged from. Psalm 51 tells us seven things that David confessed to. He needed God to have mercy on him, and blot out his transgressions. He needed to be thoroughly washed from all iniquity and cleansed from all his sin. He acknowledged

his transgressions, and that he couldn't hide from his sin. He admitted that he sinned against God, and him only. He acknowledged that he is justified in what he does, and judgest fairly in his dealings with us. He was shaped in iniquity, and in8 sin was he conceived. Truth is what God desires in the inward parts, and that wisdom must come forth, and not be hidden. Hyssop shall clean, when an individual is purged in it, if God will wash us, we shall be white as snow. Psalm 51 is a powerful psalm, if we will reflect and meditate on it.

Chapter 2

Let's reason before him

Isaiah 1:18-20, tells us to: "Come now and let us reason together, saith the Lord; though your sins be as scarlet, they shall be as white as snow; though they be red like crimson, they shall be as wool."

II Corinthians 5:11 lets us know that: "Therefore if any man be in Christ, he is a new creature: old things are passed away; behold, all things are become new."

We all have things or thoughts we need to bury or put away, whether it's envy, jealousy, grudges, profanity, discouragement, pessimism, or vain conversation.

I Corinthians 13:11 reminds us that: When I was a child, I spake as a child, I understood as a child, I thought as a child: but when I became a man, I put away childish things."

Chapter 3

We must serve the Lord

Joshua, a priest under Moses, who assisted him while they were slaves in Egypt, and after they began their journey through the wilderness of zin, after Pharaoh, by the power of God, let the Israelites leave Egypt to serve the one true, just, and faithful God. Deuteronomy 34, and Joshua 22, 23, and 24.

Moses died off the scene before the Israelites reached Canaan, the land flowing with milk and honey. Joshua then took over the leading role over the Israelites leading them beyond the Jordan River. The Israelites wanted to do their own thing but Joshua got them told.

"You can do as your forefathers had done if you wanna, "but as for me and my house, we're gonna serve the Lord (of all), my emphasis. Joshua 24:14-15, 19-20 Joshua had no choice but to come of age God's way. If he hadn't of, oohee, the Israelites would've been in a great, big, terrible fix with God, way out there in the wilderness, beyond the Jordan River. God had his hand on Joshua.

Just as he did with Daniel, David, and Paul. God will never leave Us, nor forsake us, if we do things his way.

If we abide in him. If we follow his divine regimen. Praise God! John 15:7-8 Hebrews 13:5 Deuteronomy 31:6

Chapter 4

God is not mocked

Hadassah, or Esther, the niece of Mordecai, the jew, gained renown when Queen Vashti, King Ahausuerus' wife, refused to acknowledge and present herself before him in the palace one day when he summoned her. She came of age in God when she was told by Mordecai, her uncle, that Haman, who was highly favored by the king, plotted against her and the Jews in Shushan. The Jews life depended on her stepping up to the plate for her people.

She had to approach the king on behalf of the Jews. Her own life was at stake. She had to stand up to King Ahausuerus for her people, and God interceded and prevailed in a supernatural way on their behalf, and Haman, who had plotted against them, was hung from the same gallows that he had planned to hang them on. Esther 1:12, 17; 2:16-18 7:8, 10 8:7-11

"Be not deceived, God is not mocked. For whatsoever a man soweth, that shall he also reap. For he who soweth to the flesh shall also of the flesh reap corruption, but he who soweth to the spirit, shall also of the spirit reap eternal life." Galatians 6:7-8

Chapter 5

"Here I am send me"

Isaiah in the book of Isaiah, like us had flaws, but he knew who to call on, and confess his flaws. He didn't dwell on, or waddle in his flaws. He left his flaws in the hands of an almighty God. He told his flaws goodbye. Isaiah, like David in the word of God, yearned for a clean heart and a right spirit. God called Isaiah and made him a prophet over his people Israel.

God asked Isaiah, "who will go and spread the gospel to the sinful nation of Israel?" Isaiah said, "Here am I, send me." Isaiah was excited about going to God's people Israel, and telling them that they must repent, turn from their wicked ways, and follow a righteous God, or perish.

"I am a jealous God," that's what God told Moses, his prophet, when he chose Moses to lead and deliver his people Israel out of the hand of their enemy, the Egyptians. Moses, like David and Isaiah, continued to come of age God's way. They did it man's way up until the moment they came into the knowledge of an almighty God.

Chapter 6

Building up God's House

Solomon, one of King David's sons, although he did some things that were not pleasing to God, like his father David, God made him the wisest man of his day. There was none wiser than King Solomon. I Kings 11:1-11 II Chronicles 1:10-12

David wanted to and desired to build the house of God. But because he had shed blood in abundance God chose Solomon, his son, to build an house for him. It pays to do things God's way. I Chronicles 22:5-13

The house which Solomon built to God was a great house. "For great is our God above all gods." II Chronicles 2:5

Solomon gave this prayer after the completion of the temple in dedication to the LORD: "O LORD GOD of Israel, there is no God like thee in the heaven, nor in the earth; which keepest covenant, and shewest mercy unto thy servants, that walk before thee with all their hearts: Thou which hast kept with thy servant David my father that which thou hast promised him; and spakest with thy mouth, and hast fulfilled it with thine hand, as it is this day."

Because Solomon discontinued to grow in the ways of God, God demoted him, and the kingdom were rent from him, save one tribe. I Kings 11-13

There's consequences and repercussions for not doing things God's way. "And it shall be answered, Because they forsook the LORD GOD

of their fathers, which brought them forth out of the land of Egypt, and laid hold on other gods, and worshipped them, and them: therefore hath he brought all this evil upon themselves." II Chronicles 7:22

The word of God also states that God will consume us if we be a "stiffnecked" people and will curse us if we don't abide by, and obey his laws and statutes. Exodus 32:9-10 Deuteronomy 12:28

God told Moses in the burning bush, on Mount Sinai, these words: "Thou shalt not bow down thyself to other gods, nor serve them: for I the LORD thy GOD, am a jealous God, visiting the iniquity of the fathers upon the children unto the third and fourth generation of them that hate me; and shewing mercy unto thousands of them that love me, and keep my commandments." Exodus 20:5-6

Jesus spake, telling his disciples before his death on the old rugged cross: "If ye love me, keep my commandments." John 14:15

On another occasion, while Jesus and his disciples were gathered together to brake bread, he said unto them: "A new commandment I give unto you, that ye love one another as I have loved you, that ye also love one another. By this shall all men know that ye are my disciples, if ye have love one to another." John 13:34-35

Chapter 7

Upon this rock

Peter was a fisherman by trade. But one day encountered Jesus, and his life was never the same. Jesus told him to: "Come and follow me, and I will make you a fisher of men." Matthew 4:18-19

He began to come of age in God. Once he encountered Jesus, from that moment on, he began to grow in the knowledge and wisdom of God through the Lord and Savior Jesus Christ.

But on the day of Pentecost, his coming of age in God reached an all new plateau. He gained holy ghost power beyond what he could ever had imagined. He began speaking in other tongues, and was on one accord with all the brethren in the house of God. Acts 2:1-4

Praise God from whom all holy ghost power flow.

Jesus told Peter, when it was nearing time for him to crucified: "Before the cock crow twice, thou shalt deny me thrice." Mark 14:72

Although Peter denied Jesus three times, Jesus made this declaration concerning Peter, because he saw the potential in Peter: "Upon this rock, I will build my church, and the gates of hell shall not prevail against it." Matthew 16:17-19

There is a gospel song that was popular back several years ago, called "He has me glad." It went: "He has me glad, he has me glad, I will rejoice for he has me glad." It is so assuring and comforting to know that Jesus has made me glad through his death, burial, and resurrection. Praise God!

Chapter 8

We must be born again

Coming of age God's way has a prerequisite(condition), we must be born of water and the Spirit. We can't put our earthly possessions over Jesus. This was the hang-up that Nicodemus, the Jewish teacher, carried around. Jesus told Nicodemus: "Most assuredly, I say to you, unless one is born of water and the spirit, he cannot enter the kingdom of God. That which is born of the flesh is flesh, and that which is born of the Spirit is Spirit.

Do not marvel that I said to you, 'You must be born again." John 3:5-7

Just like Nicodemus, all of us must come to the realization that we need Jesus, and that we must be born again. Therefore we must be buried with Jesus by baptism unto death: that as

Christ was raised up from the dead by the glory of the Father, we can too, if we die to sin, and walk in the newness of life. Romans 6:3-4
Baptism has dual effect: 1) Our old self dies, and 2) Our new self
is raised up with Jesus Christ. Hallelujah!

"Therefore if any man be in Christ, he is a new creature, old things are passed away; behold, all things are become new." II Corinthians 5:17

Chapter 9

Requirements for coming of age in God

1). Confession of sins. David in Psalm 51 acknowledged his sins before God. We must acknowledge that we have a sinful nature and that we have sinned before the presence of an almighty God.

I John 1:9 tells us that "if we confess our sins, he is faithful and just to forgive us our sins, and to cleanse us from all unrighteousness."

2). Seek God first. Matthew 6:33 tells us, "But seek ye first the kingdom of God, and his righteousness; and all these things shall be added unto you." Paul, before he was converted, persecuted God's people. But once he experienced and witnessed that bright light on the Damascus Road, he began seeking after God with a sincere heart. Read Acts, chapter 9.

3). Deny self. Jesus told the disciples in the twenty-fourth chapter of Matthew, that they must deny self, take up the cross, and follow him." I'm learning that to be victorious in this area, we must discipline ourselves, and make sacrifices for the cause of the kingdom of God.

4). Receive the holy ghost. Jesus spoke these words to the disciples, while he was yet with them: "But the Comforter, which is the Holy Ghost, whom the Father will send in my name, he shall teach you

all things, and bring all things to your remembrance, whatsoever I have said unto you." John 14:26

5). Grow in faith. We must put what we read, study, and meditate on to the test, and prove to God that we're real in our walk with him. "Now faith is the substance of things hoped for, the evidence of things not seen." We must follow the example of Abraham in the old testament, and the woman with the issue of blood for twelve years, in the new, are just two examples in God's word.
Genesis, chapter 22. Luke 8:43

6). Lay aside every weight. We cannot, we cannot, carry around the weight of the world on our shoulders and please and do the work of God. We must put the world's mess aside. We must strip ourselves of the world's hindrances. "Let us lay aside every weight, and the sin which doth so easily beset us, and let us run with patience the race that is set before us." Hebrews 12:1

7). Pray endlessly. We must not cease from praying. If it was good enough for Jesus, it should be good enough for us too.

Chapter 10

Benefits of Coming of Age God's Way

1). Salvation. Jesus died not to save himself, but that we, sinners by association with Adam, might receive and embrace salvation, and become a member of the family of God. "For whosoever shall call upon the name of the Lord shall be saved." Romans 10:13
2). Strength. "The way of the Lord is strength to the upright: but destruction shall be to the worker of iniquity." Proverbs 10:29

 The Lord God will be your strength. He was strength for Isaiah, David, and Nehemiah in the Old Testament, he'll be your strength too.

3). Security. We shall live secure, all of us that fear the Lord, lean and depend unselfishly on him. He wants all that we have to offer him. Our hearts, soul, mind, body, and strength. "When ye go, ye shall come unto a people secure, and to a large land: for God hath given it into your hands; a place where there is no want of anything that is in the earth." Judges 18:10
4). Safety. "But the angel of the Lord by night, opened the prison doors, and brought them forth, and said, Go, stand and speak in the temple to the people all the words of this life. And when they heard that, they entered into the temple early in the morning, and taught." Acts 5:19-23. God delivered Peter and John to safety from

the prison, because he had a work for them to do. The same way, that he kept Peter and John, in all safety from the prison guards, he'll keep us too, those that are busy doing a work for him.

5). Sound Mind. Everyone should desire a sound mind for spiritual living in God. He gives us the mind and sense to survive physically, praise God, but we need also a mind to live a victorious life in God spiritually. We need a sound mind to fight off Satan's attacks on us. "For God hath not given us the spirit of fear; but of power, and of love, and of a sound mind." II Timothy 1:7. God hath not only given us a sound mind, but holy ghost power, and his unconditional, agape' love. That's more than enough to shout about. He's given us boldness to preach the gospel, however, the holy ghost leads.

6). Steadfastness. "Be ye steadfast, unmoveable, always abounding in the works of the Lord. God wants us to be steadfast, without wavering. Satan, the deceiver, tries every device, and every trick to hinder our connection to God. We need to keep our spiritual eyes open at all times. Satan comes like a thief, to steal, kill, and destroy whatever's in his path.

7). Success. Everyone yearns for, and desires success. It's the American Dream. But, we, as fallen creatures, should yearn for and desire success that flows from God, Our Creator. It's not all about financial success, even though it's needed in this life. But we should yearn and hunger for spiritual success as well.

"Now unto him that is able to do exceeding abundantly above all that we ask or think, according to the power that worketh in us." Ephesians 3:20

Conclusion

God loved us so much that he gave his only Begotten Son, Jesus, through death on the cross. So that all who would believe on him, would inherit eternal life, and continue to come of age in him. John 3:16

Let's love and serve one another. "For the harvest is truly plenteous, but the laborers are few." Matthew 9:37

Let's continue to grow and labor in the vineyard of God.

Coming of age God's way simply means to just let God be God.

Life Lessons are a given. We must deal with them the best we know how, with the help of an almighty God.

The mountains of Life, that we face, they are no match for a triumphant, and wonder working God. He sits high, looking down on us, with his outstretched arm in the midst of it all.

www.ingramcontent.com/pod-product-compliance
Lightning Source LLC
Chambersburg PA
CBHW021026180526
45163CB00005B/2132